How to Pick the Best Style and Clothes For Your Body Type

A Step-by-Step Guide to Rebuilding Self-Love, Banishing Anxiety, and Thriving After the End of a Relationship

The Fix-It Guy

Copyright © The Fix-It Guy

Table of Contents

Introduction

Welcome, fashion enthusiasts, trendsetters, and seekers of sartorial splendor! Have you ever stood in front of your closet, desperately trying to figure out what to wear, feeling like a contestant on a fashion reality show without the glam squad? Fear not, for help is at hand!

Embark on a style revolution with "How to Pick the Best Style and Clothes For Your Body Type: Essential Tips for Flattering Your Figure, Choosing Colors, Mixing Pieces, and Crafting Your Signature Style." This isn't just another fashion guide; it's your backstage pass to unveiling the fashionista within you, and trust me, she's been dying to make her grand entrance.

Picture this: No more closet dramas, no more "I have nothing to wear" meltdowns, just you, confidently strutting through life, dressed in outfits that not only flatter your body but also reflect the fabulous person you are. We're not talking about just trends; we're talking about timeless style, the kind that turns heads and makes you the envy of every passerby.

In this book, we're on a mission together, to decode the secrets of style, to make peace with our body shapes, and to create wardrobes that are as unique as our personalities. It's a journey where fashion meets

self-discovery, and the destination? Your own signature style, one that speaks volumes without saying a word.

So, if you're ready to bid farewell to fashion faux pas, join me on this adventure. Let's transform your closet from a chaotic battleground to a curated collection of pieces that celebrate your individuality. Buckle up, fashionistas, it's time to turn your wardrobe into a personal masterpiece!

Chapter 1

Understanding Your Body Shape

Identifying Your Body Type

Hey there, fashion explorers! Ready to embark on a journey of self-discovery that's as fun as a shopping spree? Well, buckle up because Chapter 1 is all about getting to know your fabulous self, body and all!

Identifying Your Body Type

Step 1: Stand Tall and Proud
Start by grabbing a full-length mirror and giving yourself a pep talk. Stand tall, shoulders back, and remember, you're a work of art. Now, take a good look. What's your first impression?

Step 2: Break It Down
Let's simplify things. Are you more of an hourglass, pear, apple, or rectangle? Don't overthink it; your instincts are usually spot on. Think about which fruit you'd pick in a fruit salad, and voila! You've got your starting point.

Troubleshooting: "I look like a mix of fruits!"
No worries! It's more common than you think. If you're a hybrid of shapes, go with the one that resonates most or create a style cocktail that suits your taste. It's fashion, not algebra.

Embracing Body Positivity

Step 3: Be Your Biggest Fan

Now, let's kick negativity out the door. Look in the mirror again and find three things you absolutely love about your body. Maybe it's your killer smile or those strong legs. Celebrate them!

Step 4: Embrace Your "Flaws"

Those so-called flaws? They're what make you uniquely stunning. Embrace them like badges of honor. If your arms aren't sculpted like a Greek god's, guess what? You're still fabulous.

Troubleshooting: "But I've got this one thing I really dislike."

We've all been there. Turn that dislike into a challenge. Instead of focusing on what you wish was different, find styles that accentuate what you love. It's like a fashion magic trick!

Key Takeaways:

- Your body is your canvas; let's paint it with style.
- Keep it simple, hourglass, pear, apple, rectangleLove yourself. No, seriously, do it.
- Your body is a VIP, Very Important Palette for fashion.

Next Steps:

1. Strike a Pose: Pose in front of the mirror and own it!
2. Make a List: Jot down your favorite body features.
3. Fashion Vision Board: Collect images of styles you adore.

Congratulations! You've just taken the first step to becoming your own style icon. Stay tuned for Chapter 2, where we dive into the mesmerizing world of colors. Get ready to discover the hues that make you pop!

Chapter 2

The Art of Color

Discovering Your Color Palette

Welcome back, style trailblazers! Now that we've uncovered the mysteries of your body type, let's paint your fashion canvas with a burst of color! Chapter 2 is your ticket to understanding hues, tones, and shades, let the rainbow party begin!

Discovering Your Color Palette

Step 1: Play the Color Detective
Grab a bunch of colorful fabrics or clothes. What makes your eyes sparkle and your skin glow? Lean toward warm tones like reds, oranges, and yellows, or cool shades like blues, greens, and purples? Your closet holds the clues.

Step 2: Reflect on Compliments
Remember those times when someone said, "Wow, that color looks amazing on you!" Take notes. Those compliments are like golden tickets to your personal color palette.

Troubleshooting: "I can't decide!"

If you're torn between colors, start small. Introduce new hues with accessories or a killer pair of shoes. Sometimes, a touch of color is all you need.

The Psychology of Colors in Fashion

Step 3: Color Vibes

Colors aren't just pretty; they're powerful mood influencers. Red for confidence, blue for calm – it's like having a secret language with your wardrobe. What mood do you want to channel today?

Step 4: Mixing and Matching

Ever wondered why certain colors seem destined to be together? It's not just fate; it's color theory! Learn the basics, complementary, analogous, and monochromatic. Soon, you'll be a color-mixing maestro.

Troubleshooting: "I'm scared to experiment."

Fear not, my friend. Start with subtle combinations. A colored scarf or vibrant socks can be your low-risk, high-reward experiment. Baby steps into the kaleidoscope!

Key Takeaways:

- Your color journey is like a treasure hunt through your closet.
- Compliments are your color compass – follow them.
- Colors speak louder than words; choose them wisely.

Next Steps:

1. Closet Dive: Explore your wardrobe and identify dominant colors.

2. Compliment Chronicles: Recall compliments on your outfits and note the colors.

3. Mood Board Mania: Create a mood board with colors that resonate with you.

Fantastic work, trendsetters! Chapter 3 awaits, where we'll dive into the magic of building a wardrobe that not only fits your body but also sings in perfect harmony with your unique color palette. Get ready to unleash your inner color wizard!

Chapter 3

Building a Wardrobe That Flatters

Staple Pieces for Every Body Type

Hey there, fashion architects! Now that you've got your body type and color palette on lockdown, it's time to construct a wardrobe that's not just a collection of clothes, but a symphony of style. Chapter 3 is your blueprint for creating a closet that not only fits but flatters your unique self.

Staple Pieces for Every Body Type

Step 1: The Power of the Perfect Fit
Invest in staple pieces that hug your curves or provide that comfortable flow, depending on your body type. A well-fitted blazer, tailored jeans, or a little black dress can be your wardrobe superheroes.

Step 2: Embrace Your Silhouette
Let's talk about silhouettes. If you're an hourglass, accentuate that waist. Pear-shaped? A-line skirts are your best friend. Apple? Highlight those legs. Rectangle?

Create curves with belts or peplum tops. It's like custom tailoring without the tailor!

Troubleshooting: "But I want to try the latest trends!"

Absolutely, go for it! Just make sure to adapt trends to your body type. If oversized is in, choose a statement accessory to avoid drowning in fabric. Fashion is about expressing yourself, not suffocating.

Dressing for Your Lifestyle

Step 3: Wardrobe Realism

Let's be real, your wardrobe needs to fit your life. Are you a 9-to-5 warrior? A weekend adventurer? A parent on the go? Your clothes should be your sidekick, not a hindrance. Mix style with practicality.

Step 4: Function Meets Fashion

Your wardrobe should be a blend of functionality and fabulousness. Versatile pieces like a chic blazer that transitions from office to cocktails, or comfortable yet stylish sneakers for your daily hustle, are game-changers.

Troubleshooting: "My wardrobe doesn't match my lifestyle!"

Time for a wardrobe audit. Weed out items that don't align with your daily adventures. If you've got a closet full of cocktail dresses but work from home, it might be time to balance the equation.

Key Takeaways:

- Perfect fit trumps trends – always.
- Silhouettes are your secret weapons.
- Your wardrobe is your lifestyle BFF – choose wisely.

Next Steps:

1. Closet Edit: Weed out pieces that no longer align with your style or lifestyle.

2. Silhouette Experiment: Try on different silhouettes to see what suits you best.

3. Lifestyle Check: Assess your daily routine and ensure your wardrobe aligns.

Congrats, wardrobe architects! Chapter 4 is around the corner, and we're delving into the world of patterns and textures. Get ready to add some spice to your fashion blueprint!

Chapter 4

Mastering the Mix: Patterns and Textures

Pattern Play for Different Figures

Hello trendsetting magicians! Now that your wardrobe foundation is laid, it's time to sprinkle some magic dust. Chapter 4 is where we explore the enchanting realms of patterns and textures. Get ready to turn your outfits into a visual symphony!

Pattern Play for Different Figures

Step 1: Know Your Stripes
For the love of stripes! Horizontal, vertical, diagonal – each stripe has its own superpower. Vertical stripes elongate, while horizontal stripes add curves. Embrace them wisely based on your body type.

Step 2: Dazzle with Prints
Patterns are like fashion emojis; they express your personality. Florals, polka dots, or geometric shapes – choose prints that resonate with you. For hourglasses,

fitted prints enhance curves; for rectangles, opt for bold patterns to create the illusion of curves.

Troubleshooting: "Patterns overwhelm me!"
Start small. If head-to-toe patterns feel daunting, begin with statement accessories or a patterned top paired with solid bottoms. Gradually level up your pattern game as you feel more confident.

Texture Tips for a Polished Look

Step 3: Textures as Silent Storytellers

Textures add depth and interest to your ensemble. Silky fabrics exude elegance, while denim brings a casual vibe. Experiment with textures that align with your personal style and the occasion.

Step 4: Layering Loveliness

Layering isn't just for warmth; it's an art. Combine different textures to create a visually captivating look. Think a chunky knit sweater over a flowy silk dress or a leather jacket paired with a soft cotton tee.

Troubleshooting: "I feel like a walking laundry pile."
Texture blending can be tricky, but fear not! Stick to a neutral color palette when experimenting with textures. This keeps things cohesive and avoids the accidental "laundry pile" effect.

Key Takeaways:

- Stripes and patterns are your figure-flattering allies.
- Textures tell a silent style story.
- Don't be afraid to mix it up, it's fashion, not a chemistry experiment.

Next Steps:

1. Pattern Parade: Integrate a new pattern into your outfit this week.
2. Texture Tango: Experiment with layering textures.
3. Fashion Fear Tackle: Face a pattern or texture fear head-on.

Fantastic, style sorcerers! Chapter 5 awaits, where we'll dive into the exhilarating world of crafting your signature style. Get ready to put your unique stamp on the fashion landscape!

Chapter 5

Crafting Your Signature Style

Defining Your Style Persona

Hello style maestros! You've conquered patterns, textures, and silhouettes. Now, let's sculpt your fashion identity. Chapter 5 is where the magic happens – crafting a style that's uniquely, unapologetically you!

Defining Your Style Persona

Step 1: Your Style Buzzwords
Think of three words that describe your ideal style. Are you classic, bohemian, edgy, or a mix? Your style buzzwords are the compass guiding you through the fashion wilderness.

Step 2: Closet Soul-Searching
Dive into your closet and pick out pieces that make your heart do a little happy dance. These are your style anchors. What do they have in common? It could be a color, a silhouette, or a certain vibe.

Troubleshooting: "I'm a style chameleon!"

No worries, my versatile friend! If you love experimenting with different styles, create a capsule wardrobe for each. Monday can be business chic, while Friday is your boho free spirit day.

Incorporating Trends Without Sacrificing Your Style

Step 3: Trendy Teasers
Spot a trend you're itching to try? Fantastic! Now, ask yourself, "How can I make this uniquely mine?" Whether it's a funky accessory or pairing it with your signature color, put your spin on it.

Step 4: Quality Over Quantity
Trends are like guests at a party – they come and go. Invest in timeless, quality pieces that align with your style persona. They'll outlast the trend storm and become classics in your wardrobe.

Troubleshooting: "I feel pressured to follow every trend!"
Pause and take a breath. Trends are like dessert; they're delightful but best enjoyed in moderation. If a trend doesn't resonate with your style, skip it. Your wardrobe, your rules.

Key Takeaways:
- Style is personal, own it!
- Your closet is a treasure trove of style clues.
- Trends are spices, not the main course.

Next Steps:

1. Buzzword Bonanza: Define your style with three buzzwords.
2. Closet Quest: Identify your style anchors in your closet.
3. Trend Translator: Spot a trend and think about how to make it "you."

Marvelous, style architects! Chapter 6 beckons, where we'll unravel the secrets of smart shopping. Get ready to navigate the fashion aisles with confidence!

Chapter 6

Shopping Smart

Making the Most of Your Budget

Hello, savvy shoppers! Chapter 6 is your golden ticket to navigating the shopping jungle like a pro. We're diving into the realms of budget brilliance and steering clear of those fashion faux pas. Get ready to shop smarter, not harder!

Making the Most of Your Budget

Step 1: Budget Bliss
Before you hit the stores (or online carts), set a budget. It's like having a shopping compass that keeps you on track. Be realistic but leave a little wiggle room for those unexpected fashion affairs.

Step 2: Prioritize and Plan
What does your wardrobe need the most right now? Is it versatile basics, statement pieces, or maybe those killer shoes you've been eyeing? Prioritize your purchases based on what adds the most value to your current wardrobe.

Troubleshooting: "But everything is so tempting!"
Resist the impulse! Sleep on it before making big purchases. If you're still dreaming about that item the next day, it might be meant to be. If not, your budget will thank you.

Avoiding Fashion Faux Pas

Step 3: Fit Matters Most

No matter how tempting a piece is, if it doesn't fit well, it's a no-go. Resist the urge to buy something too small, thinking you'll "shrink into it." Spoiler alert: You won't, and it'll end up collecting dust.

Step 4: Trend Wisely

Trends are like shooting stars – dazzling but fleeting. Don't invest a fortune in something that might be "so last season" in a few months. Save the big bucks for timeless pieces; sprinkle trends in like confetti.

Troubleshooting: "I have a closet full of regrets."

Been there, done that. Take inventory of your regrettable purchases. What went wrong? Use these fashion faux pas as stepping stones to shopping enlightenment.

Key Takeaways:

- A budget is your shopping BFF, embrace it.
- Fit is non-negotiable; never compromise on it.
- Trends are like spice, use them in moderation.

Next Steps:

1. Budget Blueprint: Outline your shopping budget for the next month.

2. Wardrobe Reality Check: Assess your closet for regretful purchases.

3. Fit Focus: Prioritize fit over impulse.

Well done, budget wizards! Chapter 7 is on the horizon, and we'll be diving into the world of tailoring and alterations. Get ready to transform your wardrobe with the magic touch of a perfect fit!

Chapter 7

Tailoring and Alterations

The Importance of Proper Fit

Hello, wardrobe wizards! Chapter 7 is your backstage pass to the world of tailoring and alterations. Whether you're a sewing novice or a DIY extraordinaire, we're diving into the art of achieving that impeccable fit. Get ready to transform your wardrobe with the magic touch of alterations!

The Importance of Proper Fit

Step 1: The Fit Revelation
Nothing elevates your style like a garment that hugs you in all the right places. Proper fit isn't just about aesthetics; it's about comfort, confidence, and feeling like a million bucks. Say goodbye to the "it'll do" mentality!

Step 2: Tailoring Triumphs
Investing in tailoring is like hiring a personal stylist for your clothes. Whether it's shortening hems, taking in waists, or adjusting sleeves, a skilled tailor can turn a

good outfit into a showstopper. Find a local tailor you trust, it's a game-changer.

Troubleshooting: "But tailoring is expensive!"
Quality over quantity, my friend. Instead of buying five okay-fitting items, invest in tailoring one fantastic piece. It's about curating a collection, not amassing a mountain of mediocrity.

DIY Alteration Tips

Step 3: Know Your Limits
Not everyone is born with a sewing machine in hand. Start with simple alterations like hemming pants or adjusting straps. As you gain confidence, you can graduate to more complex tasks. YouTube tutorials are your best friends here!

Step 4: The Art of Cinching
Belts are your secret weapons for altering the fit of oversized items. Instant waist definition? Yes, please! It's like magic without the wand.

Troubleshooting: "I'm afraid I'll ruin it!"
Fear not, DIY maestros. Start with old clothes or thrift store finds. Practice makes perfect, and you'll be a DIY alteration pro in no time. Remember, it's just fabric – you've got this!

Key Takeaways:
- Proper fit is a game-changer – it's not just about looks.
- Tailoring is an investment in your wardrobe's success.
- DIY alterations can be both empowering and budget-friendly.

Next Steps:

1. Tailor Search: Find a local tailor and get a quote for a potential alteration.

2. DIY Confidence Boost: Start with a simple alteration project.

3. Closet Revival: Identify items that could benefit from tailoring.

Well done, alteration aficionados! Chapter 8 awaits, and we're diving into the transformative world of accessories. Get ready to elevate your style with the perfect finishing touches!

Chapter 8

Accessories: The Final Touch

Choosing Accessories That Complement Your Outfit

Greetings, style maestros! Chapter 8 is where we put the exclamation point on your fashion story with the dazzling world of accessories. From statement necklaces to the perfect pair of shoes, get ready to master the art of the finishing touch!

Choosing Accessories That Complement Your Outfit

Step 1: Assess Your Ensemble
Before diving into your treasure trove of accessories, take a moment to evaluate your outfit. Is it a canvas begging for bold strokes, or a masterpiece that needs subtle accents? Your accessories should enhance, not overpower.

Step 2: Color Coordination Magic
The color wheel isn't just for artists; it's your secret weapon for accessorizing. Complementary colors, analogous shades, or a monochromatic scheme, play with colors to create a harmonious ensemble.

Troubleshooting: "I'm overwhelmed by choices!"
Start with the basics. A versatile pair of earrings, a classic handbag, or a statement watch can be your go-to accessories. Quality over quantity, and soon you'll be curating an accessory arsenal.

Creating Balance with Jewelry, Bags, and Shoes

Step 3: Jewelry Jive

Jewelry is the punctuation of your outfit. If you're rocking a bold necklace, keep the earrings understated. Conversely, if your outfit is the star, let statement earrings shine solo. It's a delicate dance of balance.

Step 4: Bag and Shoe Symphony

Your handbag and shoes are the dynamic duo of accessories. They don't have to match perfectly, but they should be in the same style family. A structured bag with sleek heels or a casual tote with comfy sneakers – keep the vibes aligned.

Troubleshooting: "I never know when to stop!"

Less is more, dear accessorizer. If your outfit is already making a statement, opt for minimal accessories. If it's a more subdued look, feel free to let your accessories steal the spotlight.

Key Takeaways:

- Accessories should enhance, not overpower.
- Use the color wheel to your advantage.
- Achieve balance with your jewelry, bags, and shoes.

Next Steps:

1. Color Coordination Drill: Practice coordinating accessories with different colored outfits.

2. Jewelry Trial: Experiment with pairing different types of jewelry for balance.

3. Bag and Shoe Match-Up: Pair different bags and shoes to see what combinations work best.

Congratulations, accessory aficionados! Chapter 9 awaits, and we're delving into the world of dressing for special occasions. Get ready to shine at every event on your calendar!

Chapter 9

Dressing for Special Occasions

Navigating Formal Events

Hello, fashion magicians! Chapter 9 is your ticket to mastering the art of dressing for special occasions. From black-tie events to casual weekend hangs, we've got you covered. Let's make sure you're turning heads no matter the occasion!

Navigating Formal Events

Step 1: Decipher the Dress Code
Invitation says "black-tie"? It's time to unleash your inner glamazon. Cocktail attire? Think chic and sophisticated. Understanding the dress code is your first step to slaying the formal fashion game.

Step 2: The Timeless Elegance of Dresses
A classic dress is your formal event MVP. Long or short, it depends on the dress code and your personal style. Invest in one or two versatile formal dresses that can be glammed up or toned down with accessories.

Troubleshooting: "I hate wearing heels!"

Rock those flats! While heels add a touch of elegance, a pair of stylish flats can be just as chic. Choose comfort without compromising your style.

Casual Chic: Weekend and Casual Wear

Step 3: Casual with a Splash of Style
Casual doesn't mean sloppy. Elevate your weekend wear with well-fitted jeans, chic sneakers, and a stylish top. Effortless but put together – that's the casual chic vibe.

Step 4: Layers for Versatility
Layers are the unsung heroes of casual chic. A denim jacket, a cozy cardigan, or a trendy blazer can instantly transform your casual ensemble into a style statement.

Troubleshooting: "I'm tired of jeans and a tee."
Time for a wardrobe remix! Experiment with different casual pieces, wide-leg trousers, jumpsuits, or even a denim skirt. The key is variety without sacrificing comfort.

Key Takeaways:
- Decode the dress code for formal events.
- Invest in versatile formal dresses for special occasions.
- Casual chic is all about being comfortable without sacrificing style.

Next Steps:

1. **Dress Code Decipher:** Practice interpreting dress codes for various occasions.

2. **Formal Dress Hunt:** Identify a timeless formal dress that suits your style.

3. **Casual Chic Experiment:** Mix and match different casual pieces for a weekend look.

Fantastic, occasion masters! Chapter 10 is on the horizon, and we'll be delving into the realm of maintaining your style over time. Get ready for a sustainable fashion journey!

Chapter 10

Maintaining Your Style Over Time

Adapting to Body Changes

Hello, style evolutionaries! Chapter 10 is where we ensure your fashion journey isn't a one-hit wonder but a lifelong symphony. Let's tackle the inevitable changes, embrace sustainability, and keep your style timeless and evergreen.

Adapting to Body Changes

Step 1: Celebrate the Changes
Our bodies are like fine wine, they get better with time. Embrace changes as a celebration of the journey you've traveled. Adjust your style by exploring silhouettes and styles that highlight your evolving beauty.

Step 2: Wardrobe Flexibility
Build a wardrobe that's adaptable to fluctuating sizes. Invest in pieces with forgiving cuts, elastic waistbands, and adjustable features. This way, your clothes can grow and shrink with you without compromising on style.

Troubleshooting: "I miss my old wardrobe!"
Hold a mini fashion show with your existing clothes. Rediscover forgotten gems and experiment with new combinations. You'll be surprised how a different perspective can breathe new life into your wardrobe.

Sustainable Fashion Choices

Step 3: Mindful Wardrobe Curating
Before adding a new piece to your wardrobe, ask yourself: "Is this a fling or a long-term commitment?" Sustainable fashion is about quality over quantity. Opt for timeless pieces that stand the test of trends and time.

Step 4: The Art of Upcycling
Transform your old favorites into new treasures. Add patches, change buttons, or turn a long dress into a chic skirt. Upcycling not only reduces waste but also adds a touch of your unique style to your wardrobe.

Troubleshooting: "Sustainable fashion is expensive."
Think of it as an investment. Quality pieces might have a higher upfront cost, but they last longer, saving you money in the long run. Thrift stores and second-hand markets are also gold mines for sustainable fashion finds.

Key Takeaways:
- Adapt your style to celebrate your changing body.
- Build a flexible wardrobe that evolves with you.
- Embrace sustainable fashion for a timeless wardrobe.

Next Steps:

1. Wardrobe Celebration: Rediscover and showcase your favorite pieces.

2. Sustainable Shopping Spree: Invest in one quality, sustainable piece.

3. Upcycling Experiment: Give an old piece a fresh makeover.

Bravo, style evolutionaries! Chapter 11 is our grand finale, where we'll recap the key tips and set you on a path of continuous style success. Get ready to take a final bow in your fashion masterpiece!

Conclusion

And there you have it, style virtuosos, the final chapter in the grand symphony of "How to Pick the Best Style and Clothes For Your Body Type: Essential Tips for Flattering Your Figure, Choosing Colors, Mixing Pieces, and Crafting Your Signature Style." We've journeyed together through the tapestry of fashion, from understanding your body type to the artful selection of colors, mastering patterns, and perfecting the fit.

You've become architects of your wardrobe, tailors of your style, and maestros of your fashion symphony. It's not just about the clothes you wear; it's about the story you tell with every outfit, expressing your personality, and embracing the evolution of your unique self.

As you close this chapter, remember that style is not a destination; it's an ongoing, vibrant journey. Your wardrobe is a canvas, and you, the artist, have the power to create a masterpiece that evolves with time. Celebrate the changes, embrace the trends that resonate with your soul, and make mindful choices that stand the test of time.

May your closet be a reflection of your confidence, individuality, and the beautiful journey you're on. Keep experimenting, keep evolving, and, most importantly,

keep having fun with your style. You're not just wearing clothes; you're wearing your story.

Thank you for embarking on this sartorial adventure. May your fashion journey be filled with joy, self-discovery, and a wardrobe that speaks volumes without saying a word.

Until our next style rendezvous, stay fabulous, stay true to you, and keep dazzling the world with your unique fashion brilliance!

Cheers to your style masterpiece!

Printed in Great Britain
by Amazon